Mucha

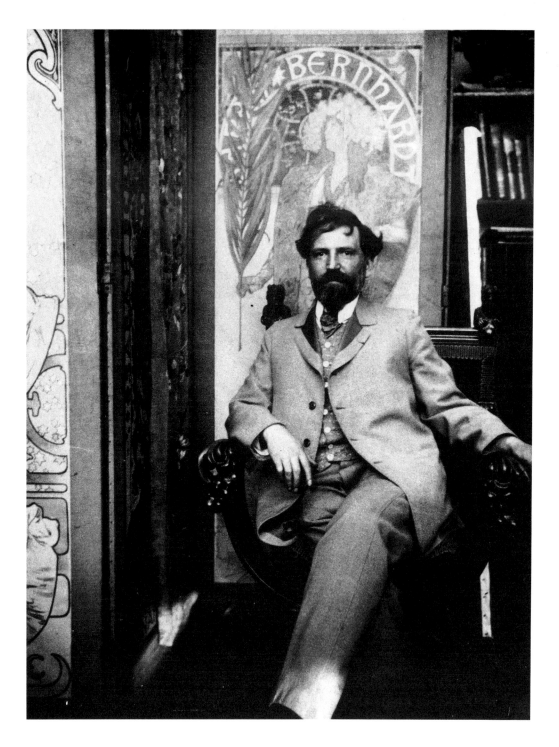

Renate Ulmer

ALFONS MUCHA

1860–1939

Master of Art nouveau

TASCHEN

KÖLN LONDON MADRID NEW YORK PARIS TOKYO

© 2002 TASCHEN GmbH
Hohenzollernring 53, D–50672 Köln
www.taschen.com
Original edition: © 1994 Benedikt Taschen Verlag GmbH
© for the illustrations: Mucha Trust / VG Bild-Kunst, Bonn 2000
English translation by Michael Scuffil, Leverkusen

Printed in Germany
ISBN 3–8228–8574–6

A87567

Alfons Mucha's is an art of seduction. His graceful women, delicate colours and decorative style add up to an unashamed act of temptation.

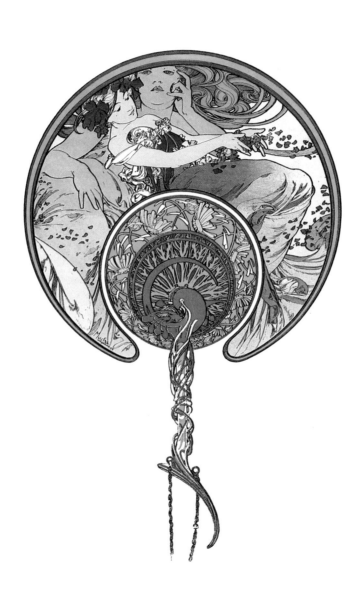

Alfons Mucha – Art Nouveau Artist

Enchanting women, streaming hair, flowing fabrics – these are the attributes one associates with Alfons Mucha's artistic *œuvre*.

Alfons Mucha was one of the most fascinating artistic personalities of the turn of the century. His work is indissolubly linked with the style whose name was at the same time its programme: Art Nouveau. In line with the new movement's demands for a comprehensiveness of design, Mucha paid homage to the ideal of artistic versatility. He was not only a painter and graphic artist, but also took an interest in sculpture, jewellery, interior decorating and utilitarian art. His particular talents, however, lay in decorative graphics. This was the basis of his fame, and remains so today.

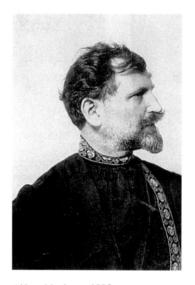

Alfons Mucha, c. 1885

Largely as a result of the already highly advanced reproduction techniques of the time, his posters, *panneaux décoratifs*, calendars, occasional prints, magazine titles and book illustrations reached an extremely broad public and attained enormous popularity. Above all, however, with their catchily decorative motifs, their inexhaustible abundance of ornamental pictorial elements, and the terseness of their calligraphically drawn lines, these compositions had in them the strength to shape a style. As the typical embodiment of the artistic endeavours of the years around 1900, the "Style Mucha" became the pattern for a whole generation of graphic artists and draughtsmen. His hallmark was the idealized, stylized figure of the beautiful or girlishly graceful woman, loosely but inseparably framed in an ornamental system of flowers and foliage, symbols and arabesques. As this was one of the most widespread pictorial motifs of the turn of the century, the "Style Mucha" came for a while to be regarded as synonymous with the whole Art Nouveau movement.

Although Moravian by birth and descent, Mucha experienced his greatest successes in Paris. His work documents the vital atmosphere of the city at a time when it was not just the capital of France, but the glittering cultural capital of the world; it captures the vitality of the *fin de siècle* and

the *belle époque* with all their worldliness and decadence, all their predilections and yearnings. He was positively showered with commissions, ranging from large-scale contracts such as the decoration of the Bosnia-Herzegovina pavilion at the Paris World Exhibition, the design of a number of theatre and exhibition poster, to advertisements for champagne, soap and confectionery. In 1900 his name was synonymous with fame, while critical opinion of his work in the years leading up to the Great War became increasingly controversial. In view of all this, it seems almost tragic that Mucha himself did not appreciate his outstanding talent as a genius of decoration and a virtuoso of form, and for a time was, if anything, worried about his reputation as the artist of a decorative style. He wanted above all to depict history, and in particular the history of his nation. It was to this task, which he viewed as a social mission, that he dedicated his entire artistic energy in the years after 1910. In the twenty monumental canvases which constitute his *Slav Epic*, he created a panorama of the history of the Slavs.

Paris – and Sarah Bernhardt

Setting his sights on a traditional academic artist's career, Mucha left Munich in 1888 for Paris in order to continue his training at the Académie Julian. Tireless studies in botanical gardens, boulevards, markets and railway stations – where he would capture perspectives, gestures and movements in his sketch-books – enabled him to develop, in addition, a virtuosity as a graphic artist. During the early 1890s, it was this that secured him a living as a talented, albeit conventional, illustrator for magazines and fashion journals. His breakthrough came with his first lithograph poster for Sarah Bernhardt and her Théâtre de la Renaissance. The anecdote attached to this is pithy enough – the emergency commission executed more or less overnight – but it is now somewhat hackneyed and its absolute truth no longer taken for granted; still, there is no doubt that it did represent a turning point in his career. The poster in question, advertising Victorien Sardou's *Gismonda*, appeared on the streets of Paris in the first

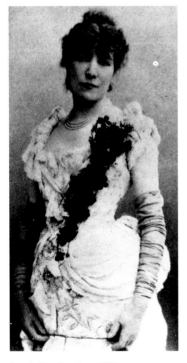
Sarah Bernhardt, c. 1885

7

week of January, 1895, and caused a sensation. The novel format – narrow and upright – with its almost lifesize likeness of the celebrated tragic actress, produced a singularly dramatic effect and impressed all who saw it with its wealth of well-chosen colour. The basis of the motif was the solemn procession scene from the final act of the play, which also determined the stylistic conception of the poster: the sumptuous, priestly-vestment-like costume, the symbolic palm-frond and the mosaic-like background with its hint of a halo all suggest a sacred atmosphere, reflecting not least the veneration of the actress as a cult figure, the muse of the *belle époque*.

This theatrical poster continues even today to be adduced time and again as a prime example of the modern conception of the poster; for Mucha, it represented a surprising step – in view of his earlier work – towards an inimitable personal style. The pictorial representation of her dramatic art had such a persuasive effect on Sarah Bernhardt that she immediately signed an exclusive contract with him for six years. The theatrical posters he produced during this period – *La Dame aux Camélias* (1896), *Lorenzaccio* (1896), *La Samaritaine* (1897), *Médée* (1898), *Hamlet* (1899) and *Tosca* (1899) – form a cycle in themselves. With their narrow format – mostly two metres high – their frontal view with its stylized outline, their lettering in the upper and lower sections of the picture and the ornamental structuring of the field, they all obey a unitary stylistic and compositional principle. Mucha understood how to depict the fascination which Sarah Bernhardt, as the lead player in her productions, used to exercise on the stage. The posters he created for her spread her popularity far beyond the borders of France.

Until 1901 Mucha was responsible not only for Bernhardt's posters but also for the stage sets and costumes of her Théâtre de la Renaissance. This overwhelming success, which also brought him considerable social prestige, determined the nature and direction of his work for years. It could be said that he was predestined for this work ever since his first artistic employment: from 1879 to 1881 he had worked as a junior in a Viennese studio specialising in stage sets. There is no doubt that he understood how to arrange scenic

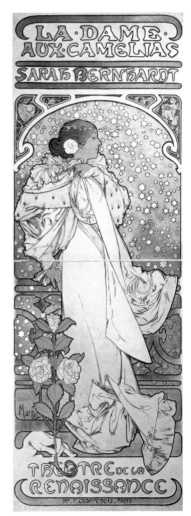

La Dame aux Camélias, 1896

events in an effective manner. Conversely, the theatre was also a source of inspiration for him. It gave him the ideas for the symbolic gesture-language of his figures and their grandiosely fantastical costumes.

It was on this foundation that Mucha built a style which successfully united the elements of various epochs with contemporary Art Nouveau decorative art. A further source was provided by the centuries-old tradition of sacred art: having grown up in a Roman Catholic environment, Mucha had been fascinated since childhood by church ornaments and religious rites and ceremonies. These impressions were reflected in the sacred aura radiated in varying degrees by many of his posters. Thus it is not just the attitude and costume of individual figures that are reminiscent of the depictions of saints in medieval, Baroque and neo-Gothic art; ornamental details, too, such as the recurrent motif of a halo-like circle behind the head, the mosaic patterns and the crosses are all unmistakably drawn from the field of religious art. In addition, Mucha, in common with many other artists of the time, was unable to ignore the influence of Far Eastern art, newly rediscovered as it was towards the end of the 19th century. Above all, the Japanese woodcut, with its linear emphasis together with its exploitation and stylistic reshaping of the forms of nature, was to point the way ahead for the exponents of Art Nouveau. However, the most fertile soil for Mucha's art was the Symbolist movement.

The Influence of Symbolism

It is well-known that in Paris Mucha maintained contact with the Symbolists and circles close to them, such as the freemasons. He must also have been acquainted with individual key works of the literature of the period which were to have a decisive influence on the pictorial language of Symbolism and the *fin de siècle*, such as Baudelaire's "Les Fleurs du Mal", Maeterlinck's "Pelléas et Mélisande" and Flaubert's "Hérodias". They contained the roots of the forms of artistic expression for representing dream-images and yearnings experienced in meditation along with a symbolism based on flowers. In contemporary paintings, for

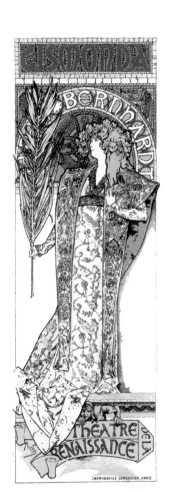

Gismonda, 1894/95

9

example by Odilon Redon, Carlos Schwabe and Gustave Moreau, Mucha also found the image of woman which, in accordance with contemporary mythology, oscillated between *femme fatale* and dreamy princess. In his own works, however, he subordinated the symbolistically inspired allegories and pictorial motifs to an overall decorative effect. Finally, Mucha drew artistic profit from the inspiring atmosphere of Parisian life as the century drew to its close. Stimulated by the pioneering graphic work of Toulouse-Lautrec, Eugène Grasset and Jules Chéret, poster art was experiencing a veritable boom. The interest taken by numerous artists in the modern mass medium of the poster was welcomed not least as an expression of the democratization of art; streets with hoardings were fêted as public art galleries. Responding to this aesthetic revaluation, even advertising posters were no longer satisfied with the hitherto standard "plain and simple" proclamation of their message in large letters, but tried rather to awaken the interest of the public by means of artistically up-market designs, which is what Mucha produced.

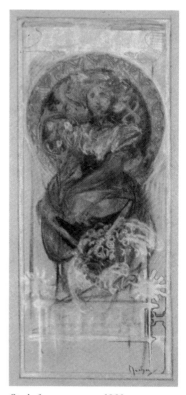

Study for a poster, c. 1900

Goddesses of Fortune

At the zenith of his creativity, in the years between 1895 and 1898, Mucha had developed not only his own style, but also a vocabulary of forms and motifs, which, capable of variation though it was, and highly adaptable in point of purpose and content, nevertheless imposed his unique signature on all his works. Thus his advertisements for industrial and commercial customers also have as their central pictorial motif the stylized figure of the female beauty. Like harbingers of a higher enjoyment of life, they hover timelessly, their expressions lost in the reverie of their own thoughts. The product being advertised – whether it be biscuits, liqueur, cigarette papers, washing powder or bicycles – is mentioned or depicted, but with discreet reticence. A striking and indispensable element of Mucha's ornamental design, by contrast, is the luxuriant coiffure of the female subject. Sometimes, indeed, it is the central feature of the composition; the whole figure is often swathed about by strands of

hair of exaggerated length, either streaming naturalistically in the wind, or else stylized to arabesques or other fanciful patterns. The decorative character of the composition is further underlined by the clinging, timeless, fantasy garments and draperies with their ornamentally elegant folds. Its ingenious simplicity gives the luxury in which Mucha clothed his female figures a yet more enhanced effect.

Mucha made particularly extravagant use of his rich vocabulary of forms in compositions such as the calendars he designed for the magazine "La Plume" and in medallions such as the *Byzantine Heads*. Exaggerating the element of grandiose stylization to the limit, he fills the whole picture with leaf and flower motifs, zodiacal signs and ornaments of the most varied kind, providing an elaborate frame for the head itself, depicted in profile. The sumptuous impression is reinforced by the many-nuanced gold and gemstone hues. Mucha demonstrated his enthusiasm for oriental show in his use of luxuriant, helmet-like headwear, which here form a prominent focus of attention. Not just the luxuriously decadent atmosphere, as propagated in, for example, Flaubert's "Salammbô", but also familiarity with Byzantine and early medieval art, together with the gemstone cult current at the turn of the century, may well have been major sources of inspiration and example.

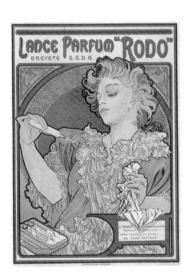

Lance Parfum "Rodo", 1896

Many Faces of Art

Following the enormous success of Mucha's posters for Sarah Bernhardt the Champenois printing works in Paris embarked on the production of so-called *panneaux décoratifs*; printed on heavy-duty paper and silk, these were framed like pictures, or else, in accordance with current fashion, used to decorate screens. Their motifs and general concept were akin to those of posters: here too, Mucha based his composition on the expressive power of a figure which filled most of the space. Most of these *panneaux* are series of four, which were all published in large editions and thus came to be widely distributed. The *panneaux* are on the borderline between utilitarian and fine art, and could even be set up scenically on a podium as living pictures. Individual

motifs were also published as art postcards, thus contributing still further to the popularity of the compositions.

Formally, the *panneaux* are based on the schema derived from the theatrical posters, albeit usually embellished with landscape details, which lend the compositions a new atmospheric quality as well as a lyrical note. They show Mucha's predilection for the personification of things and concepts, for the subjects were always connected with allegorical female figures: beginning with the first four-part series, *The Four Seasons* (1896), they symbolize *Flowers* (1898), the *Arts* (1898), *Gemstones* (1900), *Stars* (1902) and – not itself a four-part series – *The Months* (1899). Significant inspiration was provided by the English Pre-Raphaelites, about whom Mucha, in common with other artists at the time, was extremely enthusiastic. Another influence on the design of these compositions, and one which should not be underestimated, will also have come from the great picturesque decorative works of Hans Makart, for example the *panneaux* entitled *The Five Senses*. The allegorical treatment of the female subject, certain motifs suggestive of movement, a predilection for the decorative exploitation of flower and plant arrangements along with a conscious fusion of craft and visual arts – these were all aspects of the work of the great Viennese which Mucha had had the opportunity of acquainting himself with while still a young man in the Austrian capital. Tellingly, he used the same aids as Hans Makart: in particular, he used photographs of models, which he himself had taken, as the basis for the composition of his works.

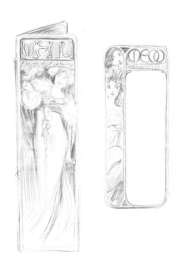

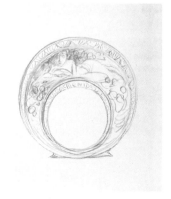

Decorative designs, c. 1900

In view of his enormous output, it is hardly surprising that Mucha sometimes ran up against the limits of his creative repertoire, with the result that figures, faces, gestures, emblems and coloration became a stereotype on which no more than a few minimal variations were played, routinely executed as any craftsman would have done. Mucha frequently accepted commissions for purely financial reasons, making concessions to the demands of the client. His artistic invention was finally diluted in the numerous menus, advertising vignettes and calendars he came to design, not to mention the mis-use of his motifs, for example for bowls made of chased tin-plate.

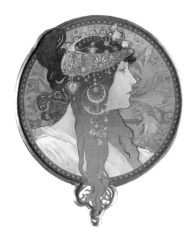

Byzantine Head: The Brunette, 1897

Jewellery for Parisian Ladies

Among the most charming creations are without a doubt the series of jewellery items that the Parisian jeweller Georges Fouquet executed to designs by Mucha. Fouquet had been struck by the unusual, highly detailed ornamentation with which Mucha had adorned the female subjects of his posters and *panneaux*. Collaboration between artist and jeweller probably started in 1898 or thereabouts. At the Paris World Exhibition of 1900, Fouquet displayed a collection of jewellery by Mucha, and caused a considerable stir. After all, the collection consisted of fantastical theatrical items, which – as was the case with the *agrafe* or stomacher – were put together from a number of components, and com-

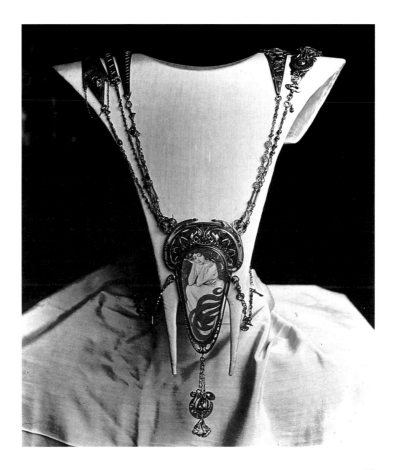

Stomacher, 1900

13

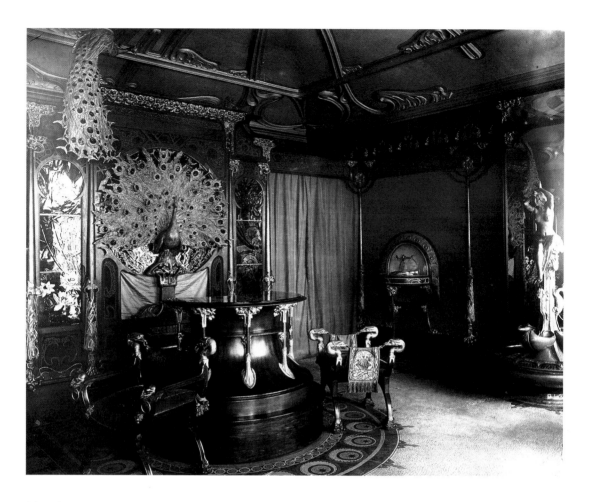

bined numerous techniques and materials: golden shoulder-chains with chased ornamental plates, semi-precious stones cut in cabochon, ivory and enamel miniatures, baroque pearls, scarabs and the like.

In accordance with the pieces of jewellery represented in his graphic works, which now in their turn provided the immediate models for the real thing, the actual pieces were overwhelmingly quasi-oriental or quasi-Byzantine. In their refined luxury, these treasures rivalled the contemporary pictorial jewellery, inspired by Symbolism, of such designers as René Lalique. In order to appeal to a broader clientele, Mucha's later pieces shed their ornamental excesses in favour of a more austere concept.

Interior decoration for Boutique Fouquet, 1901

Mucha and the "Synthesis of Art"

The association between Georges Fouquet and Alfons Mucha brought forth a further sensation: the frontage and fitting of Fouquet's jeweller's shop in the rue Royale in Paris. The Boutique Fouquet was the only commission of this type ever executed by Mucha. The result was a prime example of the synthesis of art as propagated by the protagonists of Art Nouveau, while at the same time providing a fitting, shrine-like, extravagant setting for the costly wares of the celebrated jeweller. The furniture rich in carvings and bronze fittings, tumid and sculptural in form, the coloured decorative glazing, the monumental murals and ornamental sculptures together created a theatrical and extravagant splendour in total accord with Mucha's stylistic predilections. Unfortunately this splendour was not to endure: as early as 1923, Georges Fouquet decided to refurbish his shop. All the decorative fittings were dismantled, some of them later finding their way to the Musée Carnavalet in Paris.

Façade of Boutique Fouquet, 1901

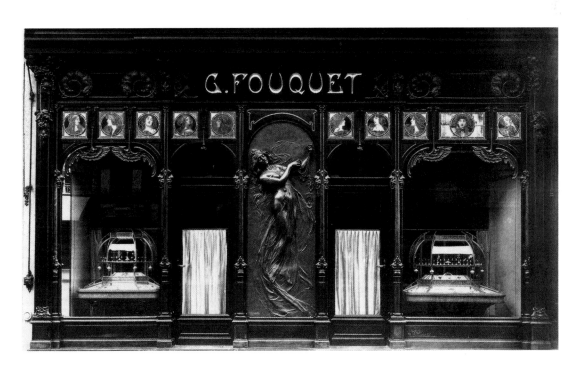

15

The Decline of Art Nouveau

The year 1902 saw the publication of Mucha's *Documents décoratifs*, a loose-leaf collection which at the same time testifies to his rich inventiveness and his success as a teacher of the decorative arts. From newly developed alphabets and minutely detailed studies of plants to designs for ornamental and utilitarian objects as diverse as items of furniture, cutlery, crockery and many more, this collection of patterns, with its typical linear and floral concepts of form and its flowing silhouettes, comes across as *the* textbook of Art Nouveau.

By 1902, however, Art Nouveau had already passed its zenith, and artistic taste was beginning to change. Yet notwithstanding the vicissitudes of fashion, Mucha clung obstinately to the style he had made his own, and continued to work in it. Perhaps he was aware of his own waning creativity and dwindling fame when in 1904 he took the decision to leave Paris for America, where at first new commissions awaited him. Even so, this sojourn in the United States, at least from the artistic point of view, did not bring the success he had hoped for.

In 1910, Mucha returned to his native country for good. The same year, his late period began with the painting of the Lord Mayor's Hall in the Festival House in Prague (obecní dům). Now able to put into practice the artistic projects formed in his youth, he devoted his energies with great perseverance and patriotic enthusiasm to the depiction of Slavic mythology. In America, he had found a rich patron in the person of the industrialist Charles R. Crane, who was prepared to finance the project. On twenty monumental canvases, Mucha, with idealistic pathos, presented the story of the Czech people. When he donated the completed cycle to the City of Prague in 1928 as the *Slav Epic*, he was deeply disappointed. The style and presentation were dismissed as reactionary academicism, and the subject matter as a form of nationalism overtaken by the facts of history. Mucha's message was behind the times.

Following decades of almost total oblivion, Mucha was among those rediscovered as interest in the art of the period around 1900 reawakened. His early work was quite rightly

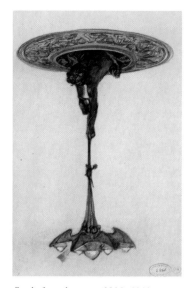

Study for a lamp, c. 1900–1902

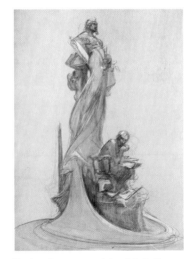

Design for a memorial to Michellet, c. 1898

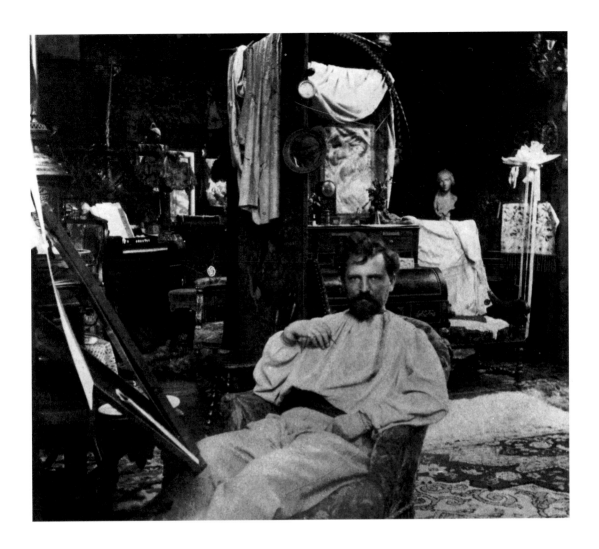

Alfons Mucha in his studio, c. 1900

accorded a major role in the appearance and development of new areas of art in the modern period. His graphic works, which were published in large editions, represented an early contribution to the movement to bring art into everyday life, as the spirit of the time demanded. As the creator of romantic dream-worlds, he was among those who raised utilitarian art from its second-rank status and on to a level with fine art, and he achieved this by setting the same standards for his posters and decorative compositions as he would for a painting.

In his realistic book-illustration style, Mucha executed four nature scenes for a soft furnishings business in 1894: *Flower, Fruit, Fishing* and *Hunting*. They were offered for sale as inexpensive copies of original works and reproduced using a technique that imitated oil painting. Comparing *Flower* with *Gismonda* (see next page), one can see the abrupt change in style which Mucha's work underwent at the end of 1894.

Flower, 1894

It is said of this poster for the Théâtre de la Renaissance that Mucha took on the commission at short notice after Sarah Bernhardt, on the afternoon of Christmas Eve, had rejected a design produced by the Lemercier printing works: the performance in question – of "Gismonda" by Sardou – was due to take place on 4th January 1895. This poster, designed by a hitherto totally unknown artist, made an immediate impression on account of the exaggerated sumptuousness of the subject and the solemnity of the atmosphere; for Mucha, it was a breakthrough.

Gismonda, 1894/95

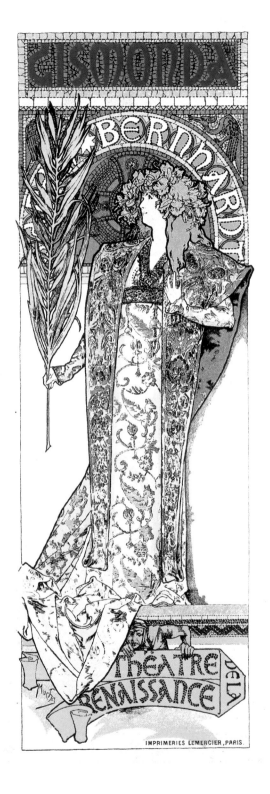

IMPRIMERIES LEMERCIER, PARIS

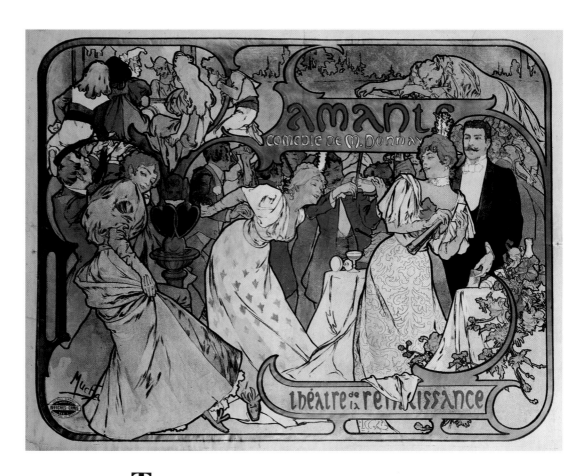

This poster is unique among those designed by Mucha for the Théâtre de la Renaissance: it is the only one not to depict the figure of Sarah Bernhardt. The transverse format and the composition with its many figures also diverge from the schema established by *Gismonda*. In accordance with the light-hearted nature of the comedy, the picture, showing a lively evening gathering with the guests in the costume of the period, conveys something of the sophisticated flair of the *belle époque*.

Amants, 1895

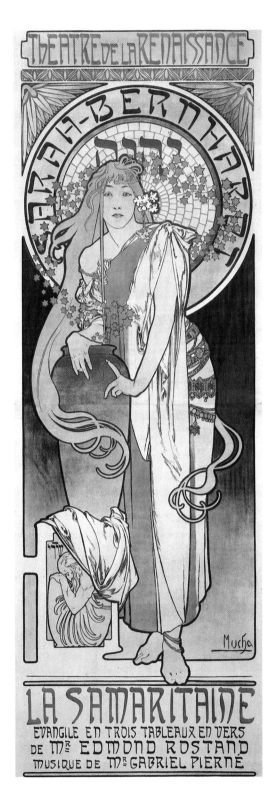

La Samaritaine, 1897

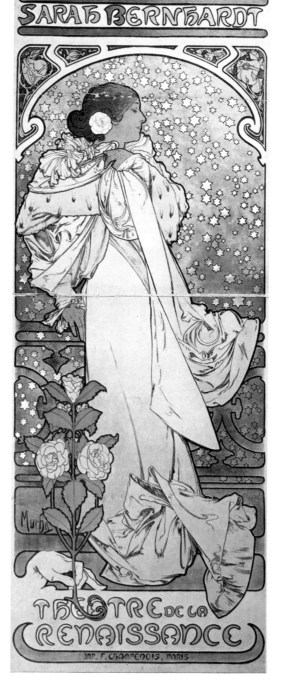

This, the third of a total of seven posters for Sarah Bernhardt's theatrical productions, is noteworthy for the manner in which the stage setting has been transferred to the graphic medium, as well as for the soft and subtle coloration. Against the back-cloth of a starry night sky, Alexandre Dumas' Lady of the Camel-lias appears "shrouded in an airy white gown, lost in the ecstasy of her passion", as a contemporary critic put it. Sarah Bernhardt had a particular liking for this poster, using it again for her American tour of 1905/06.

La Dame aux Camélias, 1896

With this highly successful poster, Mucha took his place in the celebrated Salon des Cent. His first exhibition was held under the auspices of the magazine "La Plume", whose publisher, Léon Deschamps, discovered this poster motif – with its "half-naked woman, her head encircled, halo-like, by golden hair cascading in arabesques" – almost by chance. His advice to Mucha: "Execute this design just as it is, and you will have created the masterpiece of the illustrated decorative poster."

Salon des Cent, 1896

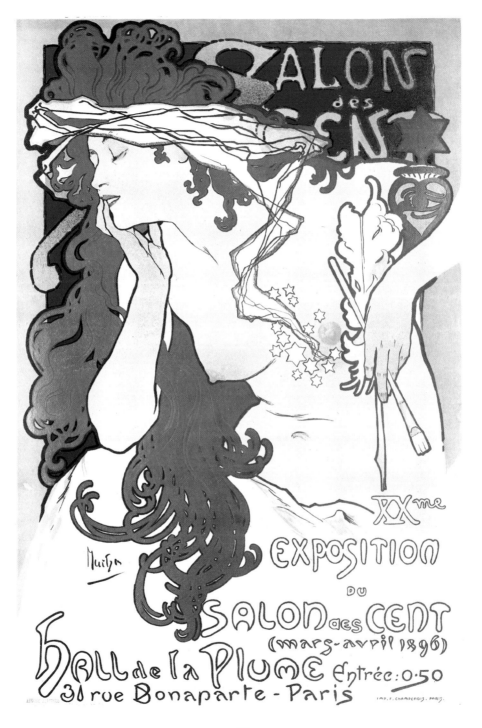

This poster for Mucha's first one-man exhibition is at the same time an example of his symbolistically-inspired pictorial language. A young girl – evidently the symbol of the visual arts – is shown holding a drawing board, on which are depicted various symbols of hidden meaning: "… a heart, threatened with thistles by stupidity, with thorns by genius and with blossoms by love", as a contemporary critic put it. An allusion to Mucha's origins is the girl's bonnet encircled with daisies, a theme of Moravian folk-art.

Salon des Cent, 1897

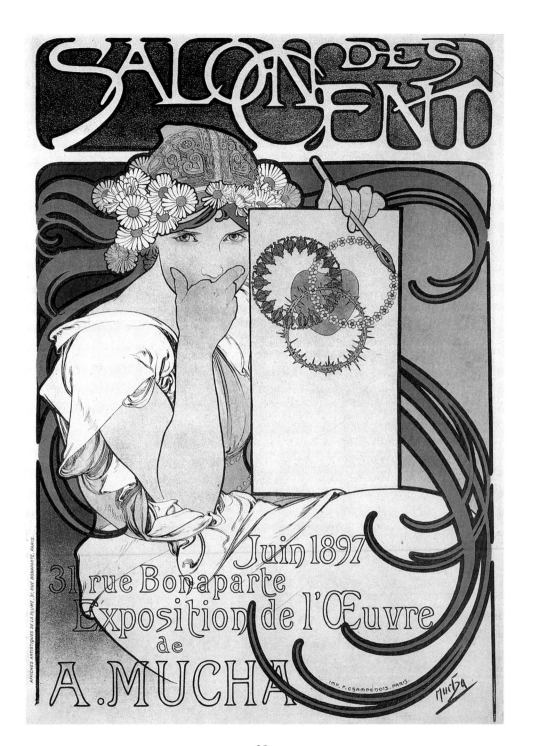

In this large-format calendar design for the Parisian art journal "La Plume", Mucha gave free rein to his wealth of ornamental inventiveness. Every square inch of the picture is covered in decorative elements of Byzantine, Moorish and Scythian origin. They form the sumptuous frame for a bust represented in strict profile. The alien splendour of her head-dress along with her aloof and sovereign attitude also give the allegorical figure of the zodiac the appearance of the priestess of some secret cult.

Zodiac calendar for "La Plume", 1896/97

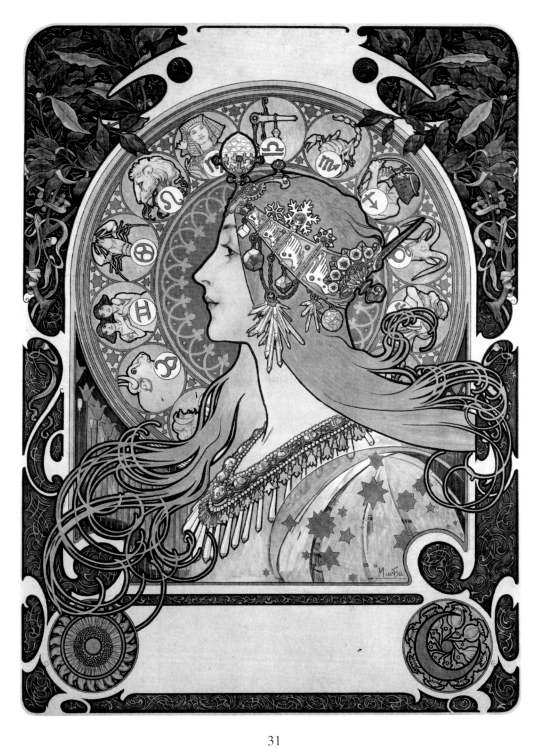

The premiere of Alfred de Musset's play featured Sarah Bern-
hardt in the eponymous (male) lead role of Lorenzaccio.
The poster, composed entirely around the expressive power of
the large-scale figure, depicts the character in dark Renais-
sance clothing, contemplating the murder of Duke Alexander.
The tyrant himself appears in the upper part of the picture in the
form of a dragon.

Lorenzaccio, 1896

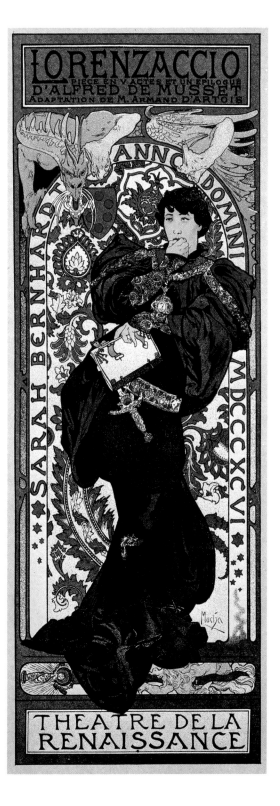

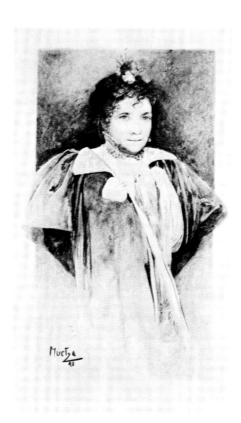

This poster was designed for the "Journée Sarah Bernhardt", an extravagant celebration which included a banquet, musical interludes and the performance of scenes on stage, all intended as a homage to the actress. The composition, with its full-face bust resembles an enlarged detail of one of the vertical-format theatrical posters, and uses the elements with which Mucha typically stylized the celebrated muse of the *belle époque* into a cult figure: behind the head is a circle resembling a halo, and the dress is inspired by medieval depictions of saints.

Portrait of a Woman (probably Sarah Bernhardt), 1898

Sarah Bernhardt, 1896

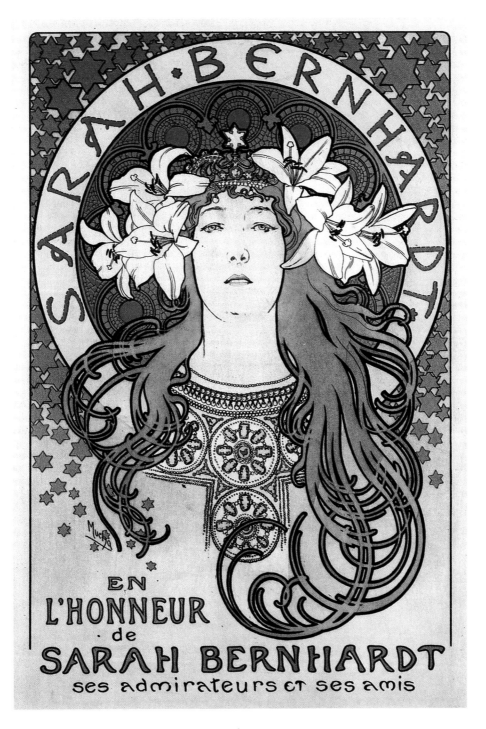

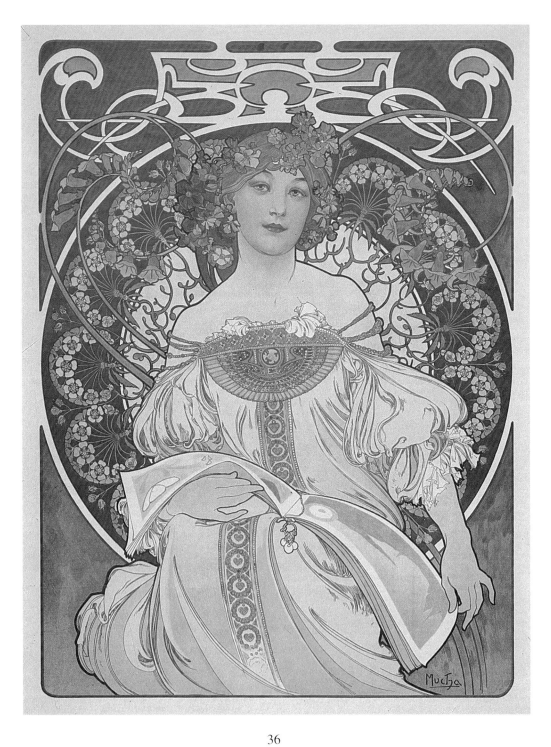

The title is symbolized by a young woman who appears to be pausing for a moment while leafing through her album. The extravagant jewellery on her breast is cleverly conceived as a component of her shawl. The motif of the woman dreaming to herself, the arabesque-like branchings of the circle of blossoms along with the dynamically formed panicles all fuse into a single decorative unit. One contemporary critic remarked that she "would be the smiling face in every boudoir".

Reverie, 1897

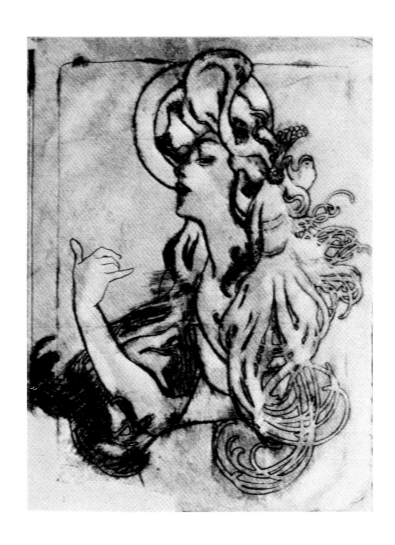

Drawing for "Job", 1896

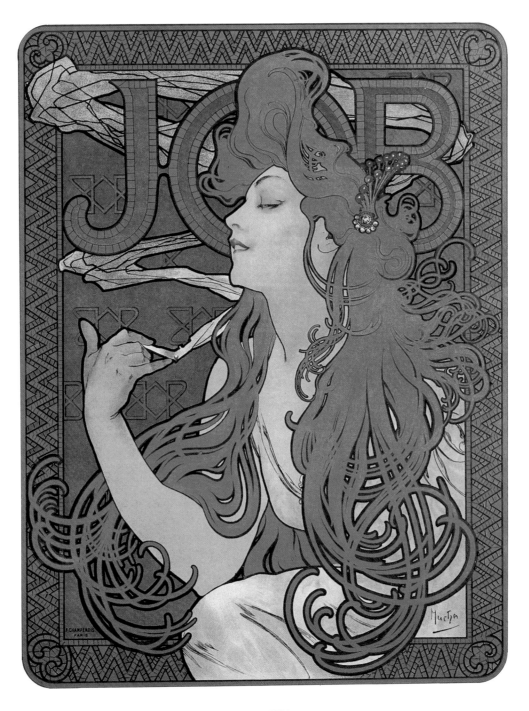

Job, 1896

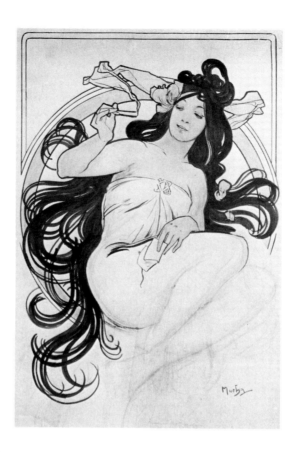

One of the Sibyls from Michelangelo's ceiling frescos in the
Sistine Chapel in Rome served as the model for this seated
female figure. Her excessively long hair with its strands coiled in
arabesques, the celebrated "maccaroni", is, by contrast, the in-
imitable hallmark of Mucha himself. This second poster to be com-
missioned by the Job cigarette company features the name of
the firm in ornamental lettering both omnipresent and discrete as
the pattern on the wallpaper-like background; it also ap-
pears as the woman's brooch, as well as on the cigarette-paper case
in her hand.

Drawing for "Job", 1897

Job, 1898

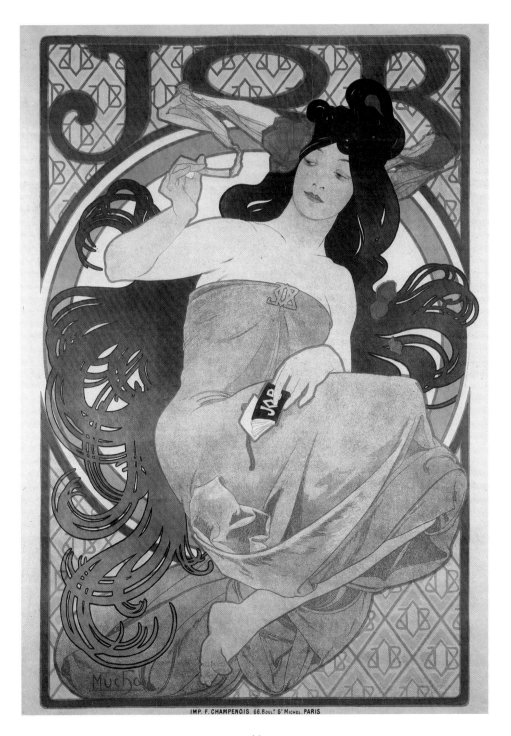

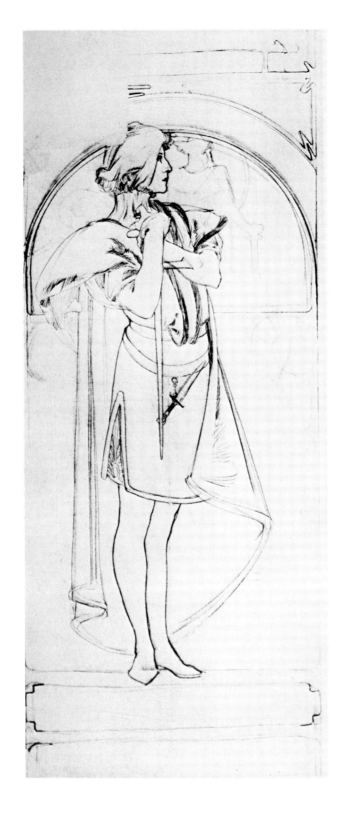

*Drawing for
"Hamlet", 1899*

42

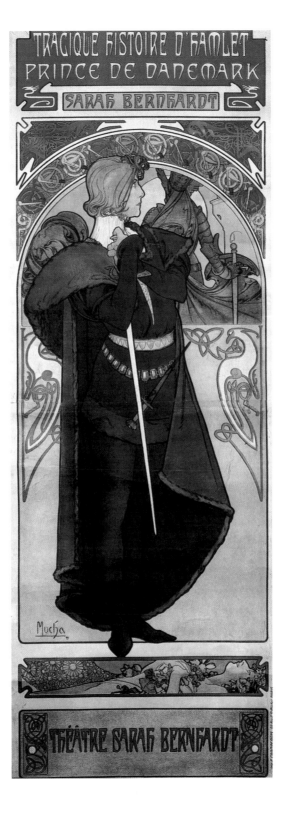

Hamlet, 1899

43

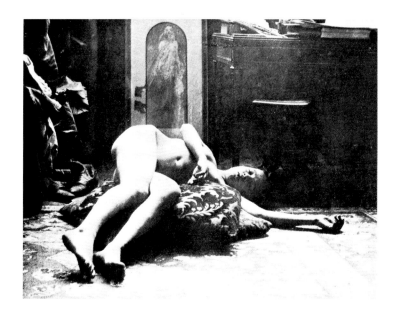

For the subject of this poster, Mucha chose one of the most dramatic scenes from Catull Mendès' tragedy: her eyes staring in horror, Medea stands before the corpses of her children, whom she has killed as an act of revenge. In the background, a baleful new day dawns. The atmosphere is enhanced by Mucha's use of red and violet hues. The classical ambience of the play, which is set in Greek Antiquity, is alluded to in such decorative elements as mosaics, pseudo-archaic lettering and palmettes.

Model photo for "Médée", 1898

Médée, 1898

44

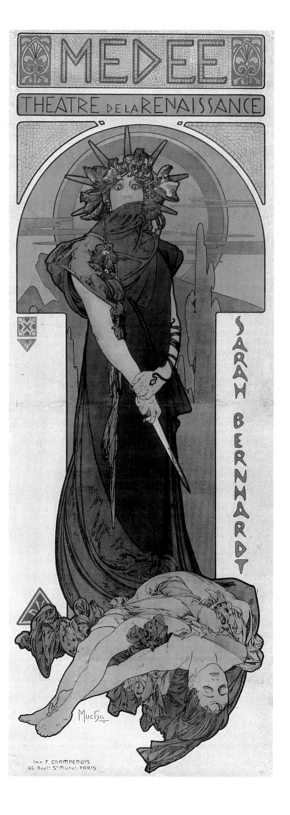

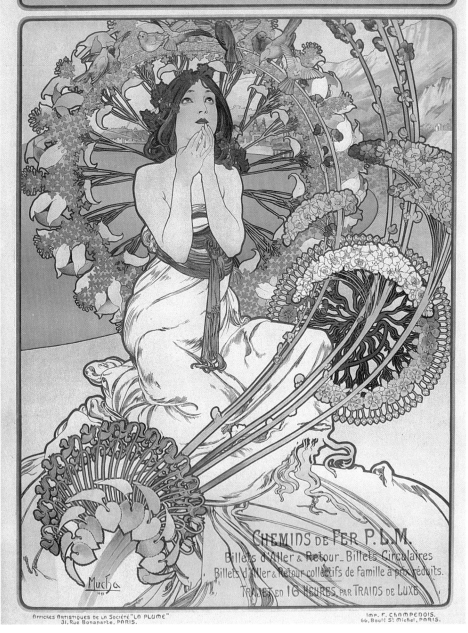

Spring Awakening on the Mediterranean" is the theme of this early example of tourist advertising. Mucha symbolizes the charm of the season and its luxuriantly unfolding Mediterranean vegetation by means of a graceful girl whose long white dress covers the ground like snow. From this "snowfield" springs a veritable fireworks display of floral garlands. The poster was originally designed for the Paris-Lyons-Marseilles railway company, but was also offered for sale to collectors of graphic art without the advertising text.

Monaco Monte-Carlo, 1897

These medallion-like compositions, bearing the additional titles of *The Blonde* and *The Brunette*, are among Mucha's most impressive creations. In addition to the subtly captured faces and the rich nuances of colour, their enchantment is due above all to the luxuriously fantastical headgear, intended to conjure up the vanished splendour of Byzantine culture. The success of this pair of pictures is evidenced by the numerous reprints, the art postcards on which they featured, and the abundance of copies. The motifs also appeared on embossed leather, enamelled metal and as cast reliefs.

Byzantine Heads: The Blonde, The Brunette, 1897

Following pages: The Four Seasons: Spring, Summer, Autumn, Winter, 1897

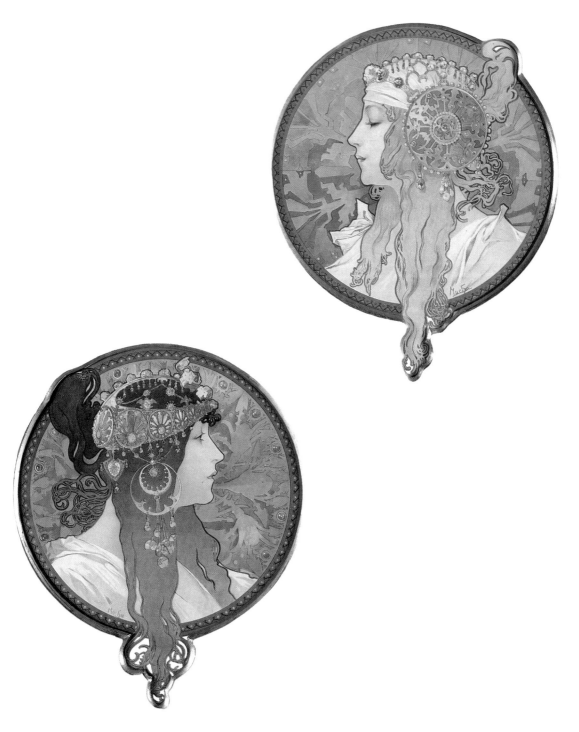

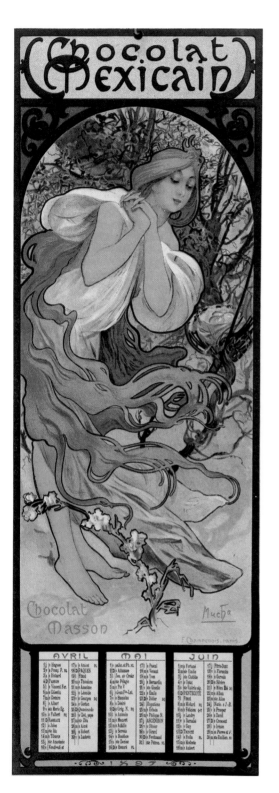

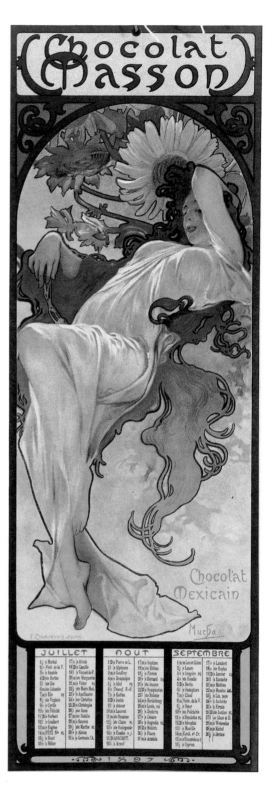

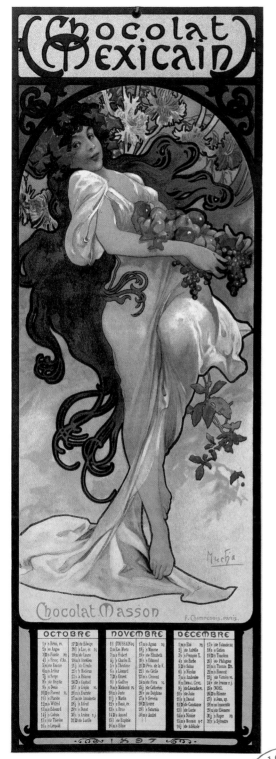

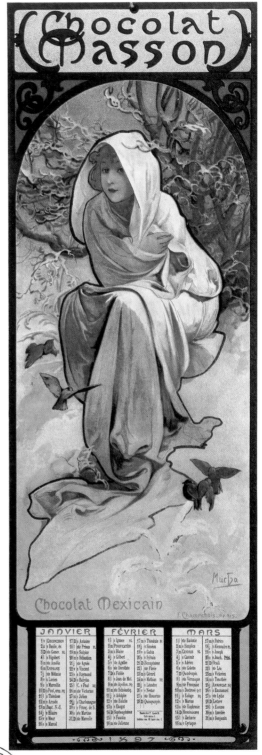

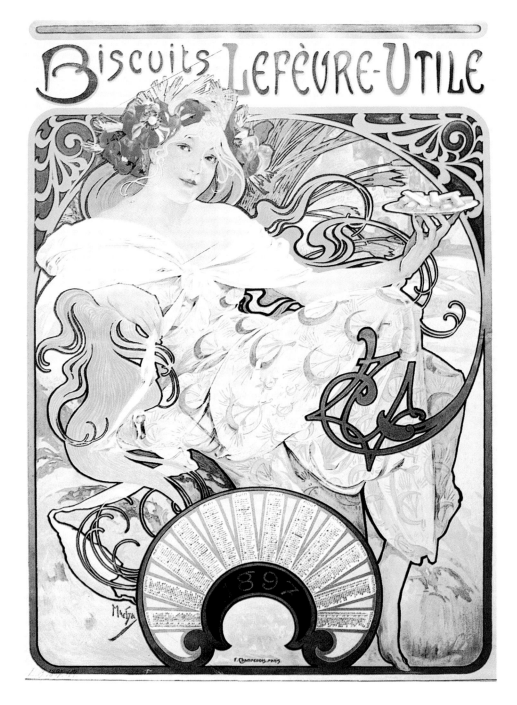

Biscuits Lefèvre-Utile, 1896

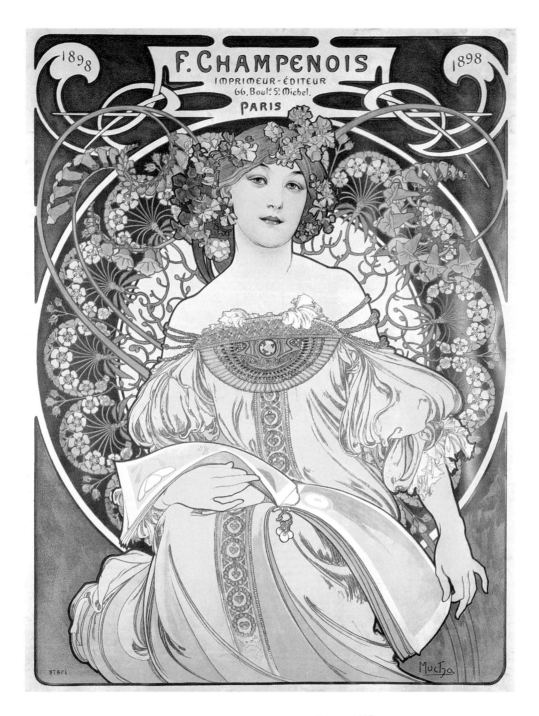

F. Champenois, Imprimeur – Editeur, 1897

53

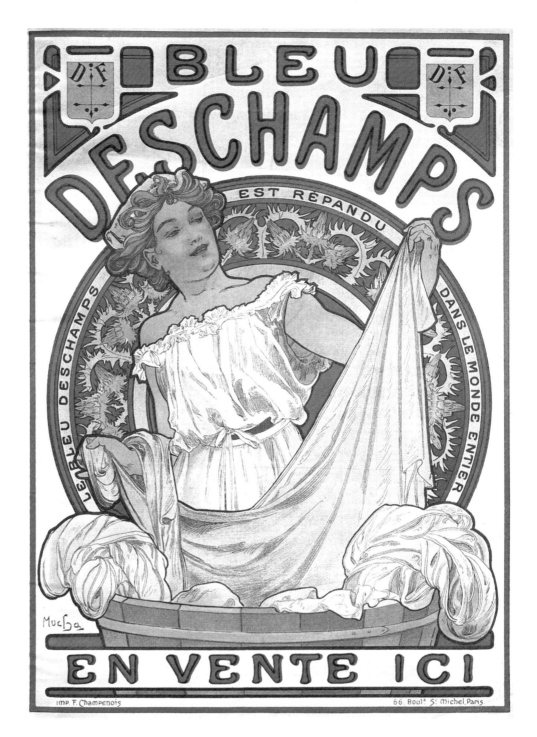

In place of a female figure who is allegorical and thus usually far removed from anything "earthly", what we have on this poster for laundry bluing is a somewhat folksy depiction of a contemporary young woman. Visibly impressed, she casts an inspecting eye over the white sheets in the wooden tub which stands in front of her. The name of the manufacturer is also written in the blue which gives its character to the whole composition. The two coats-of-arms in the top corners of the poster bear the intials "D.F." of the producer, M. Freund-Deschamps.

Bleu Deschamps, c. 1897

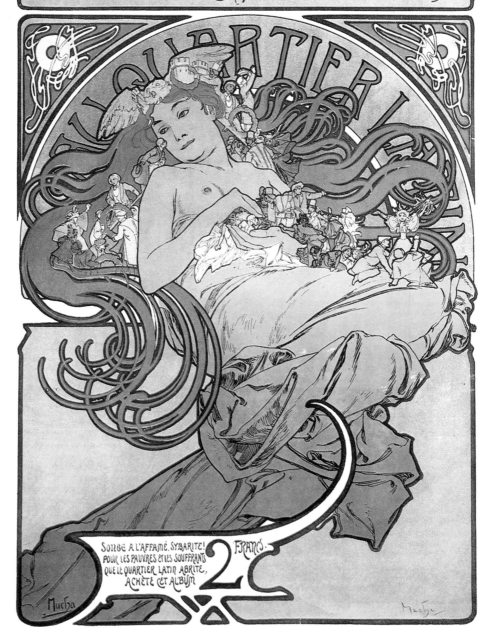

Au Quartier Latin, 1897

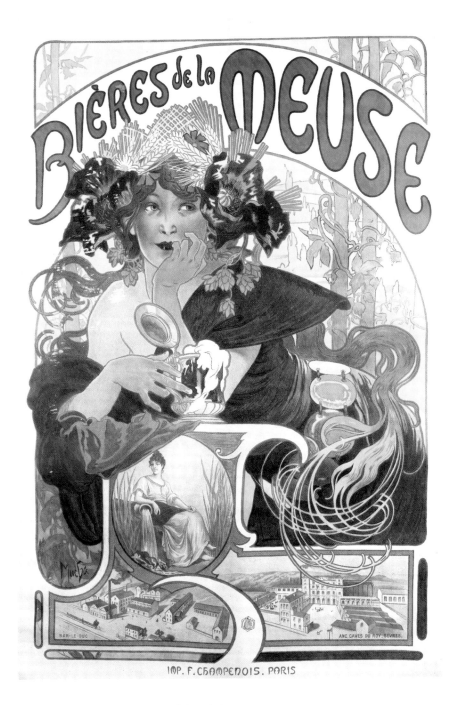

Bières de la Meuse, 1897

This poster, commissioned by a bicycle manufacturer, comes across as a detail taken from a larger composition; it addresses the beholder directly. It is a sign of Mucha's highly modern concept of advertising. Thus he does not depict a lady-bicyclist in the open countryside, in accordance with the conventions of the time, but conveys the dynamism of this means of transport by the young lady's hair fluttering in the wind as she leans over her bicycle.

Cycles Perfecta, c. 1897

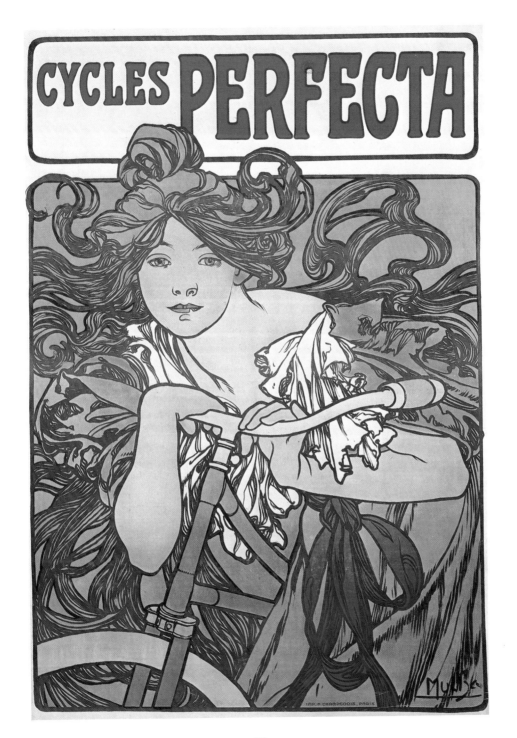

59

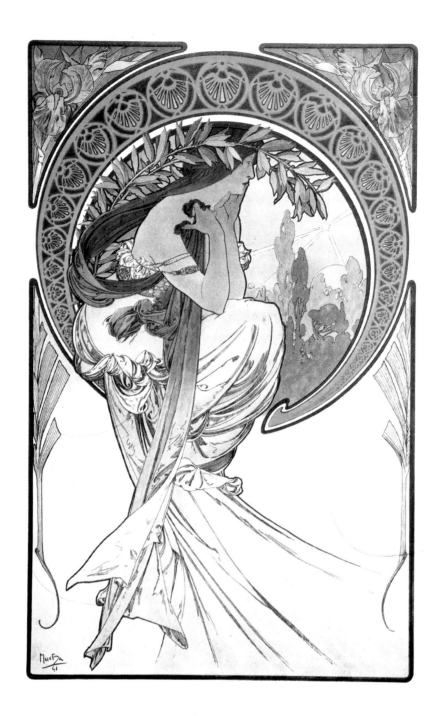

Poetry, 1898

60

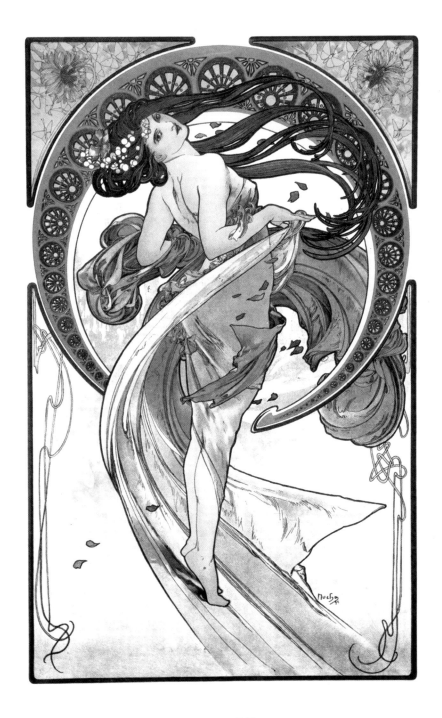

Dance, 1898

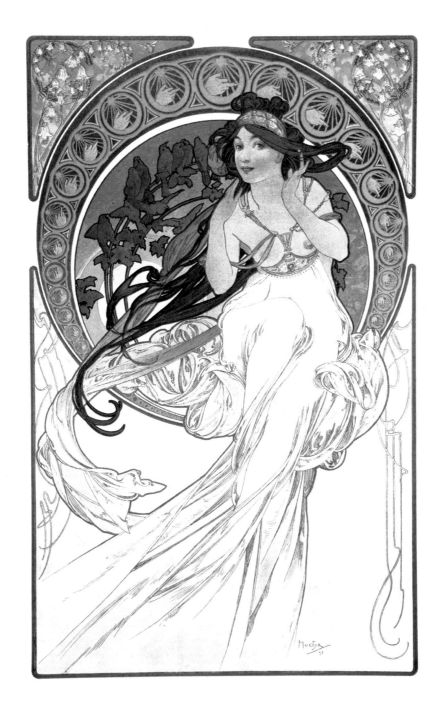

Music, 1898

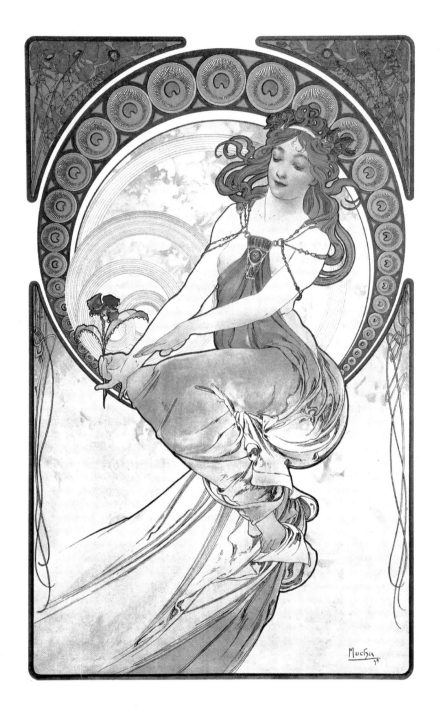

Painting, 1898

63

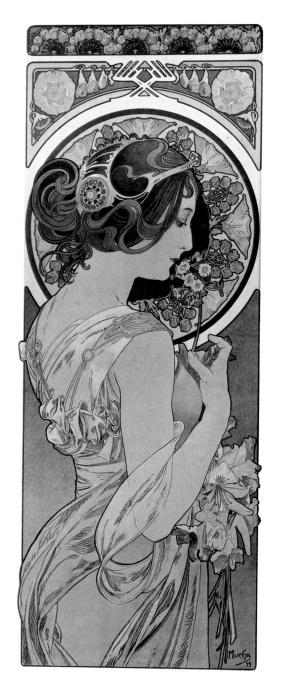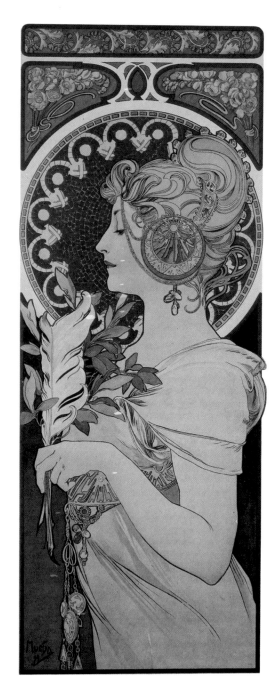

The Cowslip, The Feather, 1899

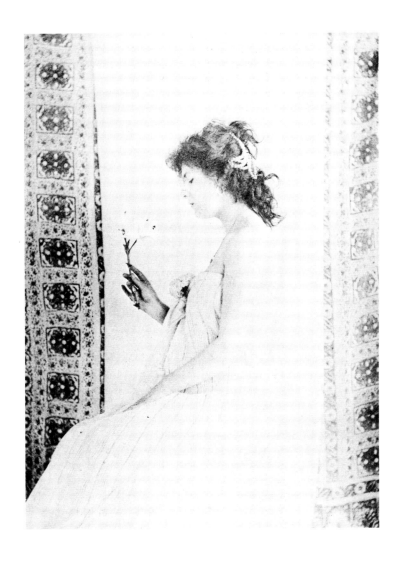

Model photo for "The Cowslip", 1899

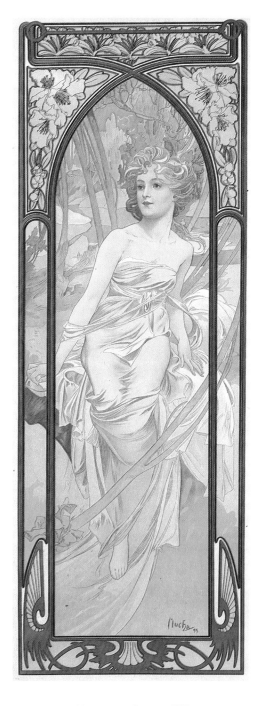

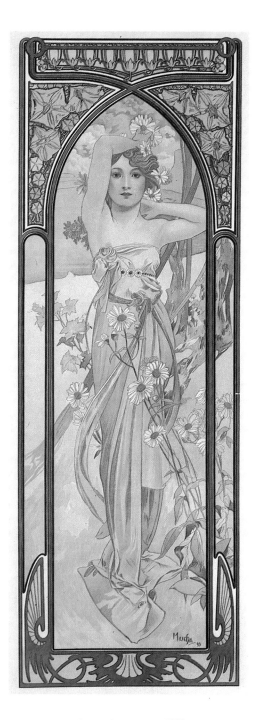

Morning Awakening, 1899

The Day's Business, 1899

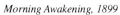

66

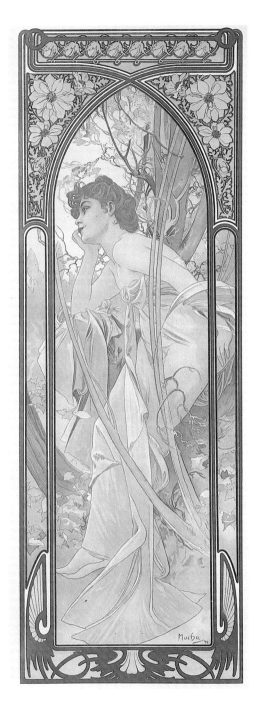

Evening Reverie, 1899 *Night Rest, 1899*

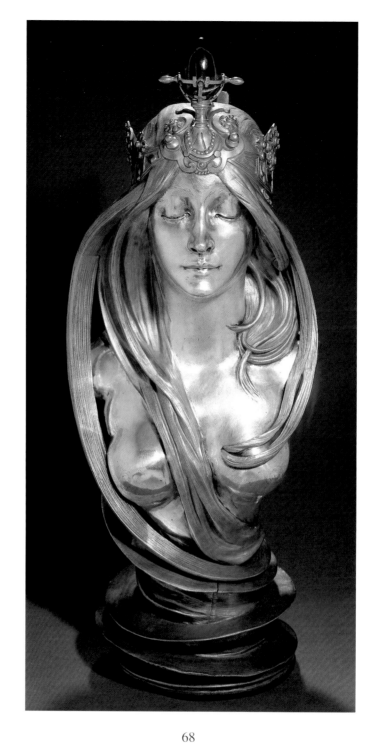

This bust, repeatedly but almost certainly incorrectly described as being that of Sarah Bernhardt or Cléo de Mérode, is of silvered and gilt hollow cast bronze measuring 70.7 × 28 × 27 cm. It is one of the masterpieces of decorative sculpture from the turn of the century. Mucha designed it for the 1900 World Exhibition in Paris. The ingenious way in which the long, open hair coils over the naked bust and around the conical trunk gives the sculpture an enigmatic character, in keeping with the contemporary image of the *femme fatale*.

Nature, 1899/1900

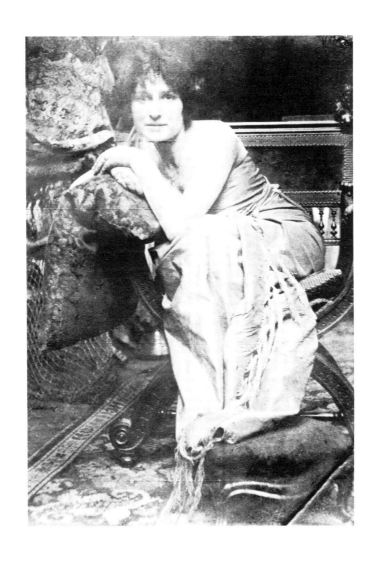

Model photo for "Emerald", 1900

Emerald, Topaz, 1900

70

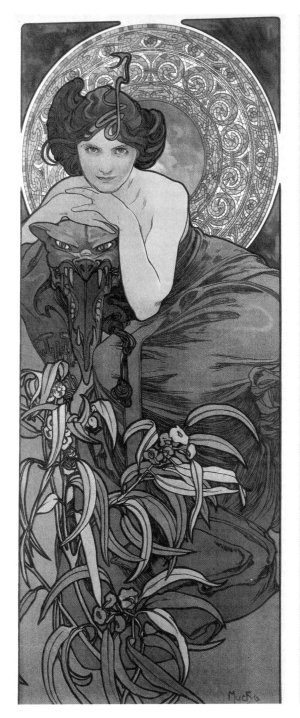

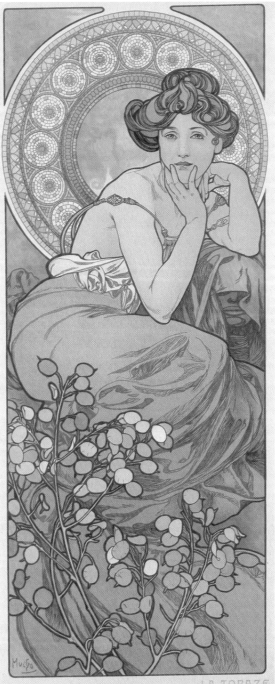

LA TOPAZE

Study for a screen, c. 1900/01

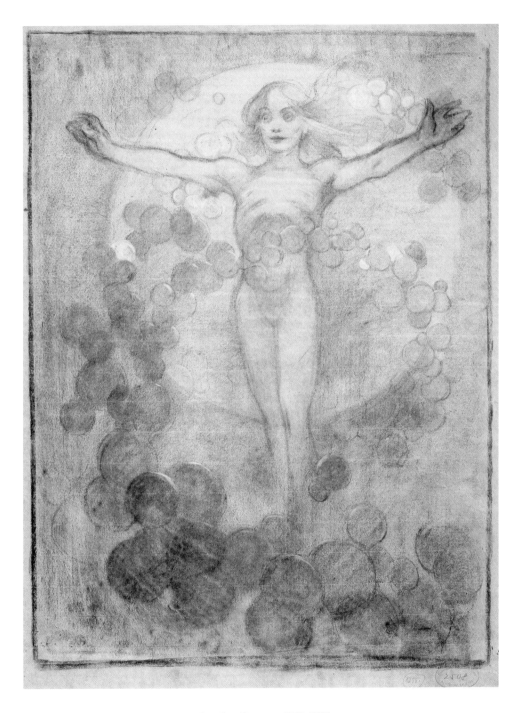

Standing figure, c. 1900–1902

This combined bracelet and ring of gold with enamel, rubies and diamonds is one of the most celebrated pieces of jewellery from the turn of the century. It was evidently commissioned by Sarah Bernhardt, for whom Mucha had already designed stage jewellery. For the bracelet, which can already be seen on the *Médée* poster, Mucha looked back to the jewellery design of classical Antiquity, in particular the Hellenistic period. Like many of his – in some cases, scarcely practical – jewellery designs, this too bears the mark of the extravagance and exoticism of contemporary stage productions.

Serpentine bracelet with ring, 1899

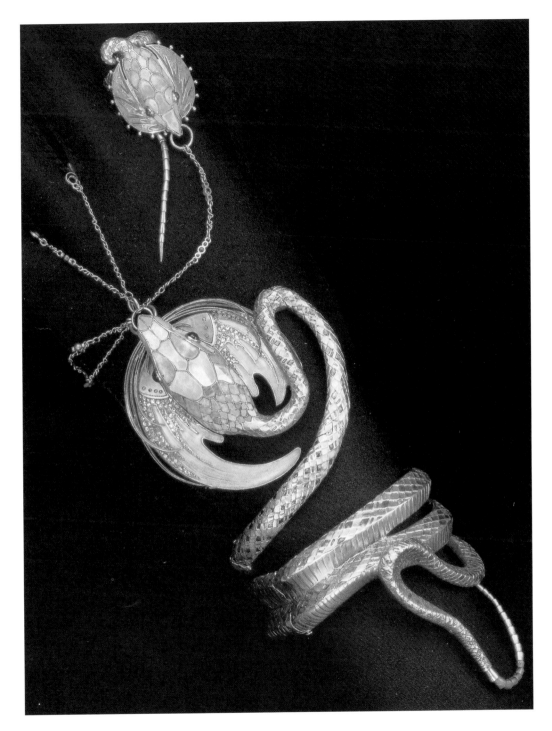

Study of a female head, c. 1900–1902

76

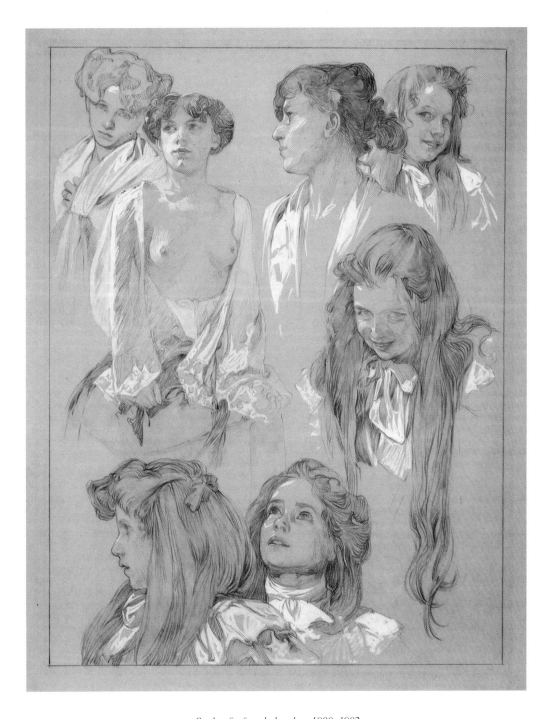

Study of a female head, c. 1900–1902

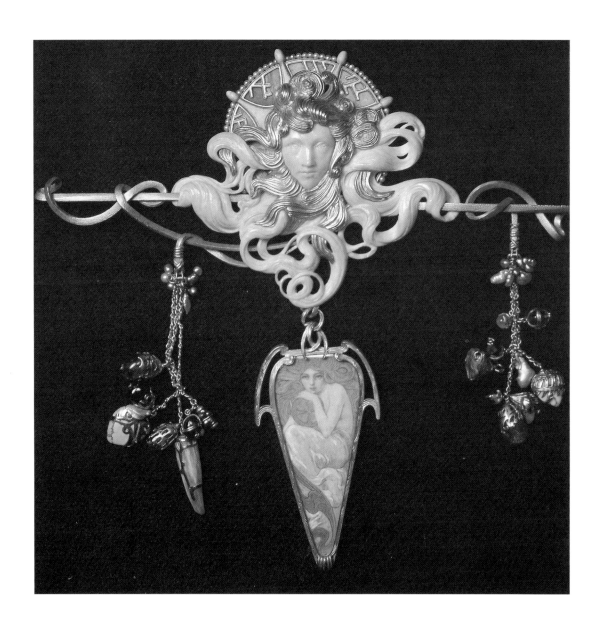

Mucha was commissioned by the jeweller Georges Fouquet to design a collection for the Paris World Exhibition. Inspired by the fantasy creations with which he was wont to adorn the female figures in his decorative graphic work, Mucha created extravagant, pictorially sculptural pieces. This stomacher of gold, ivory and pearls is indebted to Symbolism for the face, mysteriously framed in luxuriantly seething hair. This aspect was even more apparent in a setting, now lost, which had, in addition, dragon's wings at each side.

Stomacher, 1900

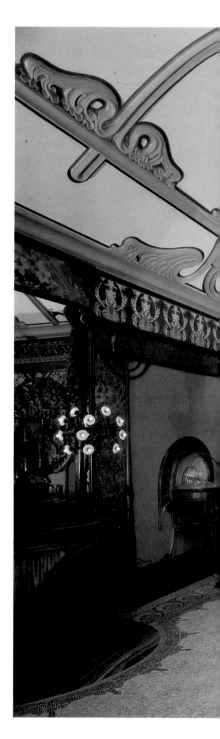

In the façade and interior decoration of Georges Fouquet's jeweller's shop, Mucha united decorative sculpture and painting, stained glass and sculptural furniture with bronze fittings to form a light-heartedly exotic environment. The design was thought out to the last details of door-knobs and fascia, and thus not only paid homage to the ideal of a "synthesis of art", but at the same time revealed the decadence of the period. However Mucha's creation at no. 6, rue Royale, lasted no longer than 1923, when it fell victim to a refurbishment. Parts of the original found a new home in the Musée Carnavalet in Paris.

Boutique Fouquet, 1900/01

80

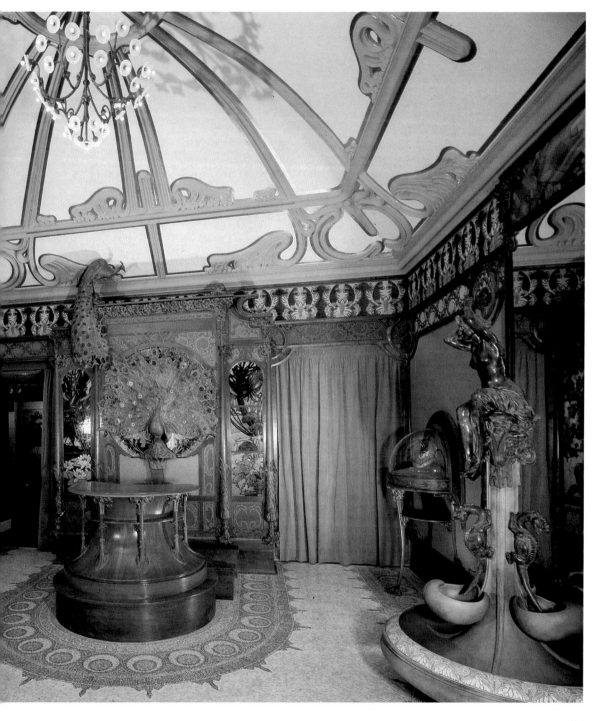

Study of a female head, c. 1901/02

Bust of a woman, 1901

82

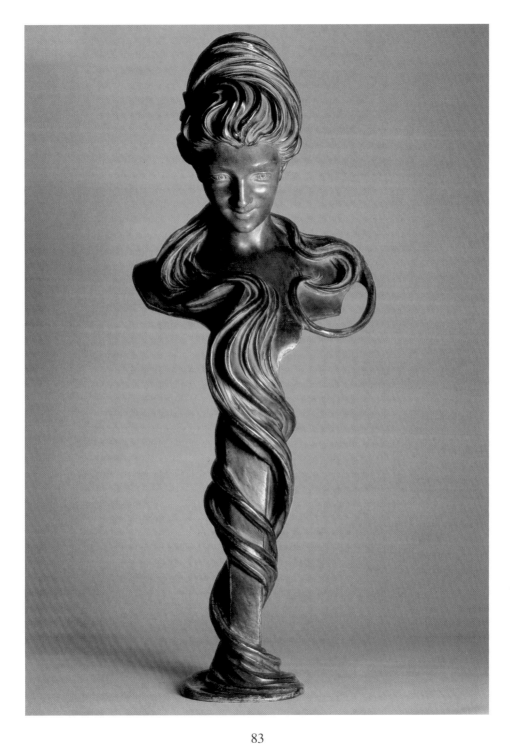

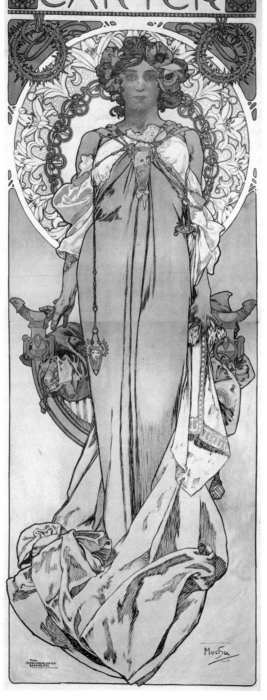

The eccentric American actress Leslie Carter sought to outdo Sarah Bernhardt in her spectacular stage appearances – which eventually led to her ruin. In point of format and style, then, Mucha based his posters for her on those he had designed for Sarah Bernhardt in the 1890s. The ornamentation includes a piece created years earlier for Fouquet. With its sugary colours and weak lines, the poster, produced in the USA, does not come up to the standard of its exemplars.

Leslie Carter, 1908

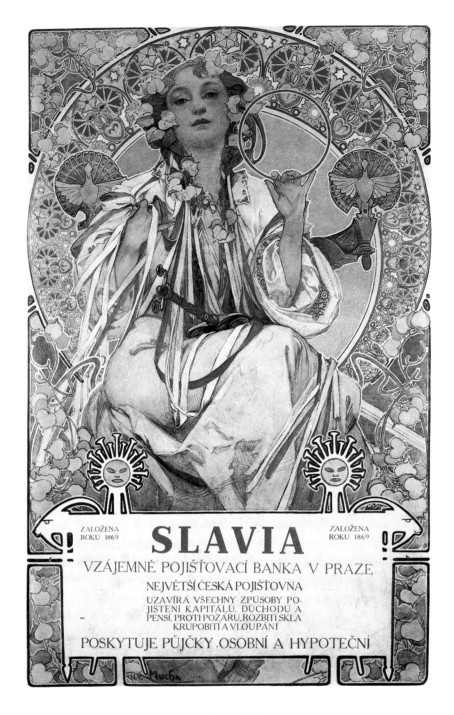

Slavia, 1896

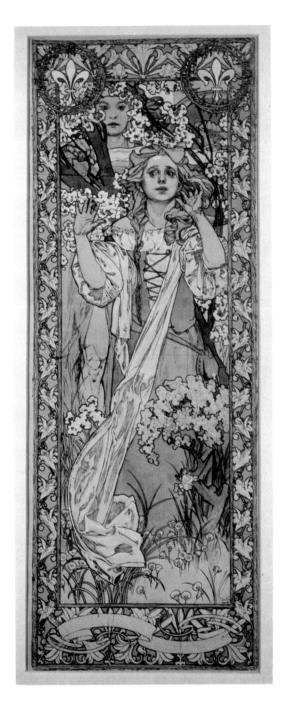

Joan of Arc (Maude Adams), 1909

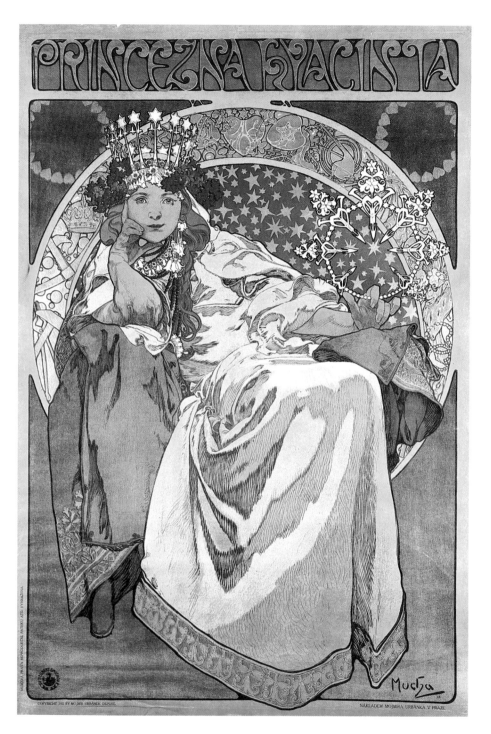

The only poster of Mucha's to be produced in his homeland was an advertisement for a mime and ballet "Princezna Hyacinta" based on the book by Ladislav Novák, with music by Oskar Nedbal. In accordance with the story, Mucha created a fairy-tale splendour. The crown of stars adorned with blossoms, the concentric circles decorated with mysterious symbols, and the suggestion of a starry background thus ring the changes on standard elements from the repertoire of motifs which Mucha had developed while at the peak of his creative powers in Paris.

Model photo for "Princezna Hyacinta", 1911

Princezna Hyacinta, 1911

89

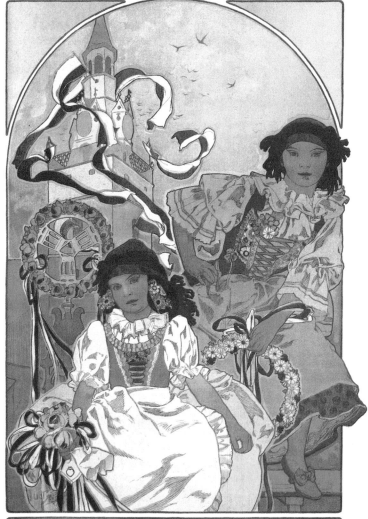

Krajinská Výstava v Ivančicích, 1912

90

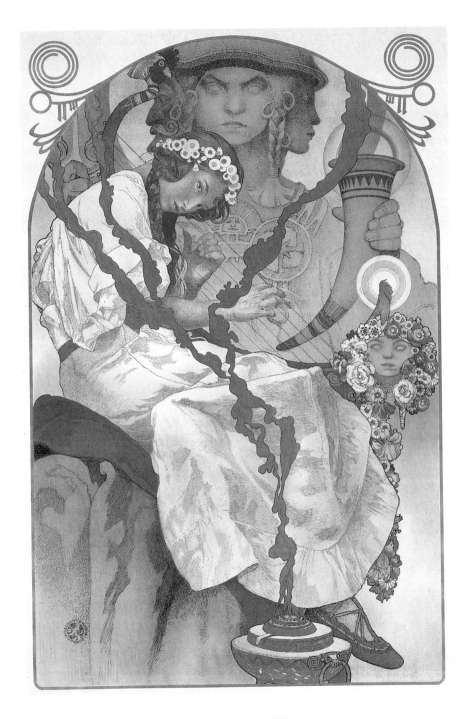

The Slav Epic, 1928

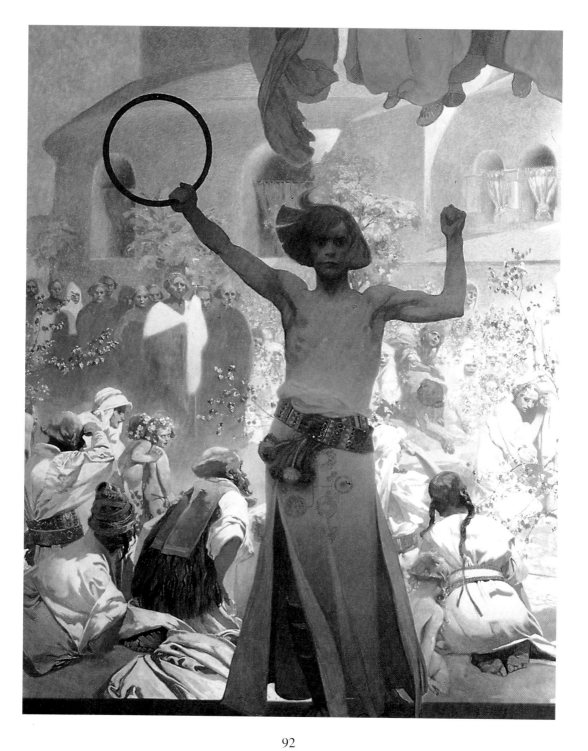

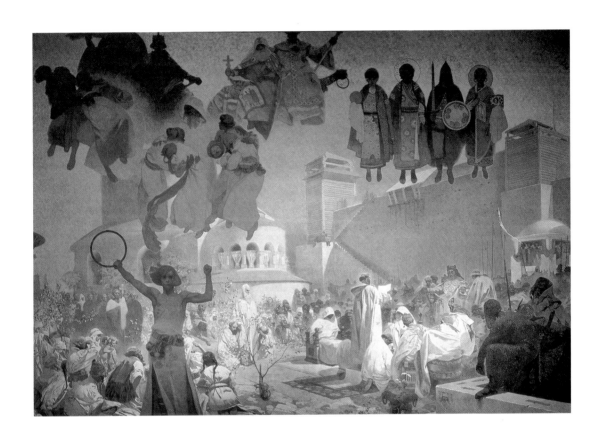

The Slav Epic, No. 3, 1912
Introduction of the Slavonic Liturgy to Great Moravia

Opposite page: detail

Life and Work

1860 On 24 July Alfons Mucha was born in the southern Moravian town of Ivančice, the son of a court usher.

1871 Mucha becomes a chorister at St Peter's Cathedral in Brno, where he also attends the local grammar school.

1875 When his voice breaks, Mucha is required to drop his choral studies, and he returns to his home town. There he becomes a municipal clerk, and continues the drawing lessons he has meanwhile started.

1877 Mucha unsuccessfully applies for admission to the Academy of Visual Arts in Prague.

1879 Mucha obtains a job as an assistant with a firm making stage sets in Vienna. Concurrently he attends evening classes in drawing.

1882 After a fire at the Burg Theatre in Vienna, Mucha is laid off. In Mikulov, he works as a portraitist, and meets Count Khuen-Belassi, his first patron. The Count commissions him to restore murals at Emmahof Palace.

1884 Mucha accompanies the Count on his travels through northern Italy and Tyrol. He is enabled to attend the Academy of Visual Arts in Munich. Mucha takes part in the activities of various artists' associations and becomes Chairman of the Association of Slavic Painters.

1888 Mucha attends the Académie Julian in Paris, and subsequently the Académie Colarossi. Alongside works in the manner of academic historical painting, he produces his first illustrations for magazines, together with occasional prints.

1892 Together with Georges Rochegrosse, Mucha is commissioned to illustrate Seignobos' comprehensive work "Scènes et épisodes de l'histoire de l'Allemagne". In addition, he designs his first advertising poster.

1894 At the end of the year, Mucha designs *Gismonda*, his first poster for Sarah Bernhardt, and signs a six-year contract with her.

1896 Alongside numerous posters printed by the Champenois company, he designs his first series of *panneaux décoratifs*: *The Seasons*.

1897 Mucha has his first one-man exhibition, staged by the "Journal des Artistes" at the Galerie La Bodinière in Paris. The catalogue, prefaced by a letter from Sarah Bernhardt, includes 107 items. A second exhibition, with over 400 works by Mucha, is held later in the year at the "Salon des Cent" and goes on tour to various European cities.

1898 Mucha gives drawing lessons at the Académie Carmen. To gather inspiration for his illustration commissions, he travels through Spain and the Balkans.

1900 The contract with Sarah Bernhardt expires. Mucha receives the silver medal for his decoration of the pavilion of Bosnia and Herzegovina at the World Exhibi-

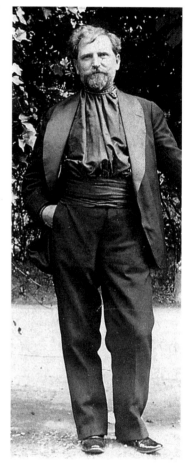

Alfons Mucha, c. 1900

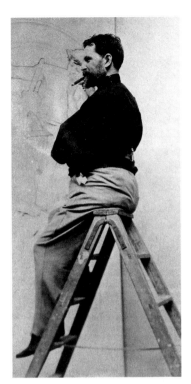

Alfons Mucha, 1896

tion. This gigantic event also features other works by him: decorative graphics, drawings, bronze figures, and pieces designed for the jeweller Georges Fouquet. He is commissioned by the latter to design the interior decoration for his shop in the rue Royale, which was destined to become one of the most perfect of all Art Nouveau interiors.

1902 In the spring, Mucha accompanies his friend, the sculptor Auguste Rodin, on a trip to Moravia and Prague. The Librairie centrale des Beaux-Arts publishes his collection *Documents décoratifs*.

1904 Mucha is invited to visit the USA, where he seeks portrait commissions in order to provide the means to carry out his slowly maturing plans for a patriotic work of art. In addition, he teaches in New York and later also in Philadelphia and Chicago.

1906 In Prague, Mucha marries Marie Chytilová, whom he had met in Paris.

1908 Following a concert by the Boston Philharmonic Orchestra, at which he heard Smetana's symphonic poem Vltava ("The Moldau"), Mucha resolves to devote himself entirely to the service of Slavic history and culture. He accepts a commission to decorate the newly established German Theater in New York, whose existence was, however, destined to be brief.

1910 Mucha returns to his homeland and rents a studio and an apartment at Zbiroh Castle in western Bohemia. Until 1913, he travels regularly to Paris in order to spend part of the year there. He devotes himself with increasing intensity to his work on a planned cycle of paintings to be called a *Slav Epic*. In addition, he works on the decoration of the Lord Mayor's Hall in the Festival House in Prague (obecní dům).

1921 Following the exhibition of the first eleven paintings of the *Slav Epic* cycle in Prague in 1911, Mucha displays some of these monumental works with great success in Chicago and New York.

1928 Mucha moves to his own house in the Bubenec district of Prague. In October he announces the solemn presentation of the twenty monumental paintings constituting the *Slav Epic* to the Czech people and the City of Prague.

1931 Mucha designs the window for the new archiepiscopal chapel of St Vitus' Cathedral in Prague. In addition he designs, as he had done several years before, banknotes for the Czechoslovak republic.

1936 Mucha publishes his memoirs "Three Statements on my Life and Work". The Musée du Jeu de Paume in Paris stages an exhibition of works by Mucha and František Kupka.

1939 Mucha dies of pneumonia in Prague on 14th July. His last painting is *The Slavs' Oath of Unity*.

The publishers would like to thank the picture archives, photographers, museums and owners for their contributions on the following pages:

Archiv für Kunst und Geschichte, Berlin: 52, 53
Artothek, Peissenberg: 21, 24, 33, 56, 57, 60, 61, 62, 63, 64, 65, 71, 87
Musée des Arts décoratifs, Paris: 13, 14, 75, 83
Badisches Landesmuseum, Karlsruhe: 68
Bibliothèque Forney, Paris: 41
© Christie's Colour Library, London: 19, 31, 50 left, 50 right, 51 left, 51 right
Kunstgewerbemuseum, Prague: 49
Museum Fridericianum, Kassel: 10, 12, 16, 72, 73, 76, 77, 82, 92
Museum für Kunst und Gewerbe, Hamburg: 22, 27, 39
Pierre Lehmann, Geneva: 46
© Photothèque des Musées de la Ville de Paris, Paris: 81
Plakatsammlung, Museum für Gestaltung, Zurich: 11, 23, 29, 35, 36, 45, 46, 84, 91
Musée de la Publicité, Paris: 42